Cezanne
A–Z

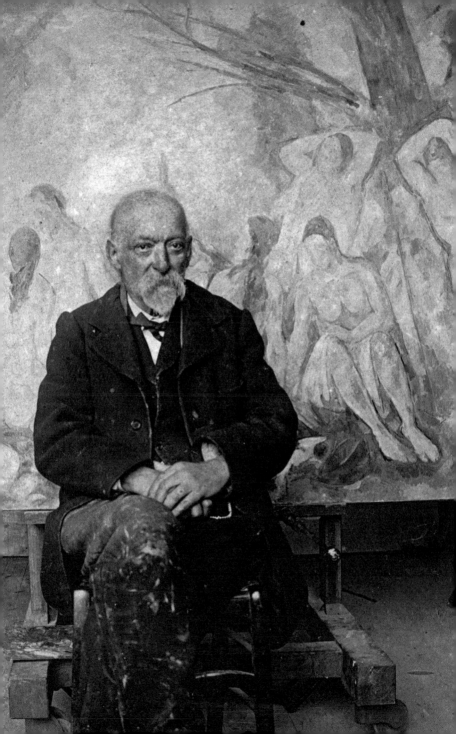

# Paul Cezanne
# A–Z

## James H. Rubin

## Foreword

Since graduate school, when I decided a PhD thesis on Cezanne would take the rest of my life, and despite some articles and chapters devoted to the painter, plus many publications focusing on others, a book on the great Provençal master has until now eluded me. The A–Z concept narrows the framework, and the general audience to which it is addressed it forces a condensation of one's ideas—limitations I found both challenging and refreshing. At the same time, I have in general tried when possible to build from each entry, or at least many of them, towards a cumulative effect. Although the book represents my current ways of thinking about Cezanne, my hope is that it will lead to many fruitful future thoughts both for myself in a more thoroughly researched essay, and for others.

I follow the recommendation of the *Société des Amis de Cezanne*, based in Aix-en-Provence, to drop the accent in Cezanne's name, returning to its original Provençal spelling. Cezanne added the accent in order to clarify pronunciation of his name in Paris, but he did not use it to sign his paintings.[1]

# A → Aix-en-Provence

A   Historic view of Le Cours Mirabeau
    Aix-en-Provence

    Schematic map of Aix and environs
    from *Les Sites Cézanniens du Pays d'Aix* (Paris, 1996)
    pp. 234–35

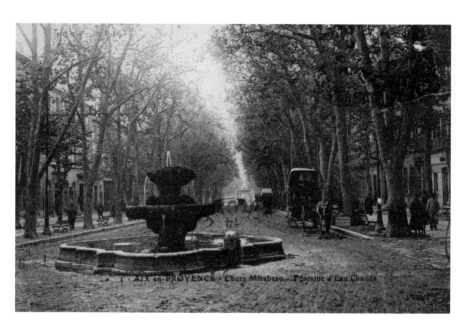

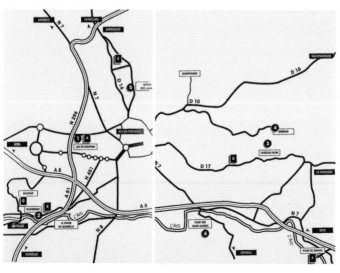

Paul Cezanne's birthplace (January 19, 1839) and home city, Aix—meaning "water" or "watering place" for the thermal baths built on Roman ruins there—is a place with deep historical roots and a balmy inland Mediterranean climate. Once the seat of a regional *parlement*, as it was called in French, it is the site of stately aristocratic town houses (*hôtels particuliers*) on one side of the old city, and narrow, intricate shopping streets and bustling outdoor cafés on the other.→p. 8 Today, Aix is filled with tourists, many of whom follow the *Chemin de Cezanne* (Cezanne trail), an itinerary indicated by metal sidewalk plaques that lead upward to the painter's final studio on the Lauves Hill, called *l'Atelier des Lauves*. Beginning with its establishment in 1902, the painter walked there nearly every day from his flat at 23, rue Boulegon, about fifteen minutes away in town.

At Aix, Cezanne's father, Louis-Auguste Cezanne, had risen from a hatmaker to become a rich banker, the epitome of the self-made man. With his wealth, he acquired a large, wooded farming estate called the Jas de Bouffan.→ Jas de Bouffan Having afforded his son a classical education as a boarder at Aix's Collège Bourbon, he was disappointed when Paul insisted on becoming a painter rather than following the pre-ordained path to a lucrative profession in law or banking. During his upbringing and studies, Cezanne met the future journalist and novelist Émile Zola → Zola, Émile along with other lifelong friends with

intellectual and artistic ambitions. Among them were the naturalist Antoine-Fortuné Marion, with whom he hiked in the countryside and discovered fossils, Baptistin Baille, who became a professor of optics and acoustics, the painter Antoine Valabrègue, and the journalist Numa Coste, who also painted.

With the exception of his earliest decades in Paris, Cezanne spent practically his entire career in Aix, especially following his father's death in 1886, when the Jas de Bouffan became his permanent home until its sale in 1899. Cezanne's most famous landscapes are sited in areas surrounding Aix,→p.8 many of which have retained much of their original character. →Quarry He felt so profoundly identified with his region and its provincial status that he often accentuated his southern accent when in Paris. It was a time of fierce regionalism opposing the centralizing power of the national government. Cezanne was also following the example of the militant Realist painter from the Franche-Comté province, Gustave Courbet, whom he took as a model for an outsider challenging the established institutions and their old-fashioned academic conventions, which still held sway in Paris.→Classicism

B→ Bathers

Among Cezanne's most ambitious paintings are large nudes in landscape settings. Such scenes had both a personal and art-historical significance for him. On the personal side, they likely recalled the halcyon days of Cezanne's youth, when along with his comrades he swam naked in the River Arc, near his home in Aix. Of at least equal if not greater importance was the presence of such scenes in revered pictorial traditions. The nude figure set into a landscape was a staple of the classical repertory,→ Classicism echoing not only tales of the ancient Roman writer Ovid, but the images of gods, goddesses, and nymphs prolific in old-master art since the Renaissance. There could be found a certain classicism Cezanne claimed he wished to recover.

In 1862, the radical painter Édouard Manet had taken a scene of river gods from the great Italian painter Raphael as the basis for a parody of the bather scene, which he converted to a modern picnic. Originally entitled *Le Bain* (The Bath, or Bathing), now known as *Le Déjeuner sur l'herbe* (Luncheon on the Grass),→ p. 13 Manet's picture was eliminated by the jury for the official government-sponsored art exhibition of 1863, called the "Salon." It became notorious when, following protests by many artists, Emperor Napoleon III decided to authorize a *Salon des Refusés* held in an annex to the Salon, allowing viewers to decide for themselves the worthiness of rejected works. For the young Cezanne,

**B** Édouard Manet
*Le Déjeuner sur l'herbe* 1862–63
Oil on canvas 208 × 264.5 cm
Musée d'Orsay, Paris

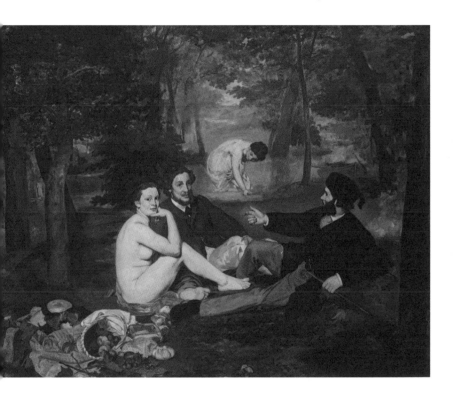

B  *Male Bathers at Rest*  c.1876–77
   Oil on canvas  82.2 × 101.2 cm
   Barnes Foundation, Philadelphia

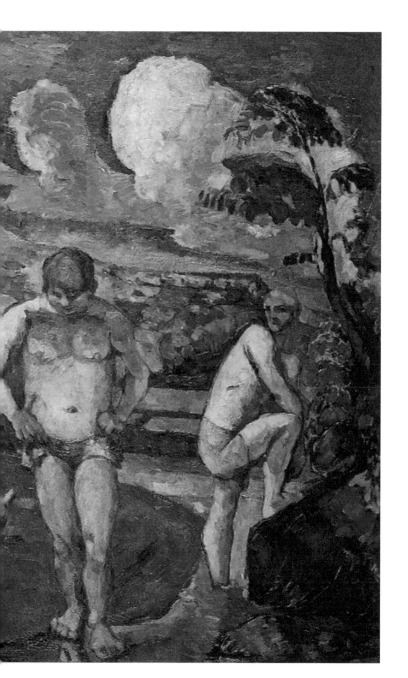

B *Standing Bather* c. 1885
Oil on canvas 127 × 96.8 cm
Museum of Modern Art, New York
Lillie P. Bliss Collection

*The Great Bathers* 1894–1905
Oil on canvas 127.2 × 196.1 cm
National Gallery, London

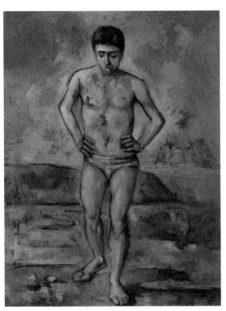

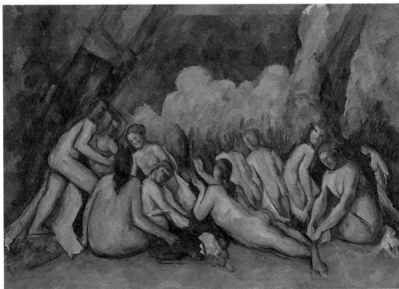

Manet became a foil in the 1860s, in part because his childhood friend Zola →Zola, Émile began to defend Manet in the press. Manet had updated the classical theme by dressing its participants in contemporary clothing and locating them in a Paris suburb along the River Seine, where weekenders enjoyed fresh air and bathing. His figures were elegant portraits of men who were related by family, as well as an obvious professional model, the entire composition certainly produced in the studio.

By deliberate contrast, the Impressionists, followed by Cezanne, rejected Manet's staged realism; they worked directly from nature out of doors. Yet, at the same time, Cezanne was tempted by the traditions of the great masters, which he hoped to "redo after nature," as he supposedly once stated.[2] →Nature The primary vehicles for those ambitions were his bather scenes, through which he evoked timelessness and grandeur as if to recapture the classicizing quality Impressionism had discarded through its emphasis on daily life. He cast his figures nude or nearly so in their settings, and he generalized their features. Their backgrounds were non-specific, or, at most, generic echoes of Provence. A relatively early *Male Bathers at Rest* has Aix's famous Mount Sainte-Victoire →Mount Sainte-Victoire in the distance.→pp. 14/15 In that picture, a sort of demonstration piece, he posed figures in a variety of positions, echoing—but in that effect only—academic exercises intended to

17

show one's mastery of the figure from different viewpoints.

The bather theme became especially prominent in large-scale compositions later in Cezanne's career, as in his *Great Bathers*,→p.16 where the nudes are both more abstracted and yet grouped more naturally than in *Bathers at Rest*. Beside them are the dog, sometimes known as Black, and a picnic cloth with fruit, recalling the scene's inspiration in modern leisure and in Manet. Finally, one of the greatest male nudes in modern art is certainly Cezanne's single *Male Bather*,→p.14 with its combination of a relatively naturalistic youth standing like a Greek *ephebe* full length against the landscape setting. His pensive expression endows the whole with a sense of timeless dignity. It is one of his few pictures aided by a photograph (which other painters sometimes used as well), especially for the position of the arms. Otherwise quite transformed in the picture, the source can be said to emphasize Cezanne's aim to make of nature (as here recorded by photography) an art that was solid and lasting, "like the art of the museums."[3]

C → **Classicism**

Both are terms widely used in art history and therefore require explanation when used in discussions of Cezanne. Both are important to an understanding of his ambitions, often exemplified by his paintings of bathers.→Bathers Until the mid-nineteenth century and in many cases long afterwards, the two terms, though not interchangeable, were overlapping. Academicism refers to the teachings of the French *École des Beaux-Arts* (School of Fine Arts), generally known in art parlance as the Academy (but not the same as the French Academy itself, which consists of intellectual and artistic luminaries).

One of the art academy's aesthetic principles was admiration for the classics, meaning not just Greek and Roman so-called classical art, sculpture in particular, but also Renaissance art, including the old masters of painting epitomized by Raphael but including many others. In emulation of these classics, the Academy's technical teaching placed an emphasis on tight, precise drawing and high finish. The sketch-like spontaneity of Impressionism was considered inadequate to the methodical, systematic processes of academic art production, which emphasized a work ethic in which careful labor was taken as the sign of a painting's maturation.

Clearly the Impressionist style, derived as if instantaneously from scenes observed directly from everyday contemporary life, challenged both the academic preference for traditional

themes evoking the past and techniques requiring deep knowledge of traditional practices.

Cezanne in his early years had spent a great deal of time in museums, as his sketchbooks full of copies of old master works and a number of his early figure compositions reveal. As suggested in the discussion of his bather compositions,→ Bathers the poses and the simplifications of his figures sometimes echoed classical art. In addition, although his technique was based on Impressionist patches of color, Cezanne's version of it was systematic,→ Serial Brushstrokes and his compositions were calculated, even though derived from direct observation. These aspects echo the academic value placed on labor and mature thought. Finally, just as classical statues were understood to be enduring aesthetic models, Cezanne's paintings seem to embody the sort of permanence and gravity associated with classical art despite their subject matter in landscape, portraiture, and still life. The Academy had always focused on literary and historical narratives or on nostalgic landscapes from afar, whereas Cezanne's motifs, not just in landscapes but even in his choices of pottery for still life, were local. When one speaks of classicism in Cezanne's work, therefore, one must not confuse it with academicism. Cezanne's technique was very different, and while often systematic, it was never rote. Although he may have had the prestige of museum art in mind, his ambition was to make such art from nature itself.→ Nature

# D→ Dramatic Paintings

Cezanne's earliest works, besides landscape sketches and portraits, include a significant number of ambitious subject paintings, →Bathers including images of religious ecstasy and scenes of violence with murder →pp. 24/25 and abduction. →pp.133/134 All are conveyed through brutally direct and powerful brushstrokes thickly laden with often dark and lurid colors. →Y Chromosome Such works were likely inspired for their themes by the sensationalist tenor of popular contemporary novels, including his friend Zola's *Thérèse Racquin* (1867), in which a woman and her lover plan the murder of her husband. This early Romantic, or what might be called the "protest" phase of Cezanne's career, may also be associated with the regional styles of painters such as Adolphe Monticelli, a fellow Provençal, but also with the great Romantic painter Eugène Delacroix, whose work Cezanne deeply admired. The latter's death in 1863 seemed to enhance the admiration of younger painters for his expressive handling of color and loose brushwork.

With these and various rivalries on his mind, Cezanne prepared a large portrait of his painter friend Achille Emperaire, who was a dwarf and hunchback. →p.27 Across the top in letters imitating the stenciling for a shipping container, the title ostentatiously proclaimed the sitter's identity. It will not be forgotten that Napoleon I's nephew, Louis-Napoleon, was France's authoritarian ruler in the 1860s, echoing his uncle as Emperor Napoleon III. Cezanne used Emperaire's

D    *The Murder  c.1870*
      Oil on canvas  65 × 80 cm
      The Walker Art Gallery, Liverpool

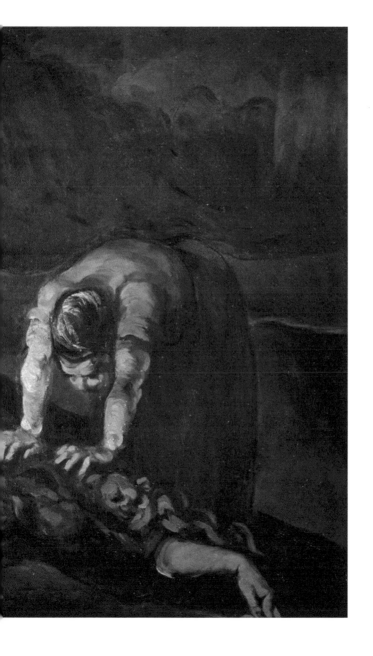

name to make a vicious pun on the emperor, and his composition parodied the conservative classicist painter Jean-Auguste-Dominique Ingres's *Portrait of Napoleon on the Imperial Throne*.→p. 27 Cezanne showed Emperaire in a bathrobe and pajamas, his spindly legs propped on a foot-warmer, mimicking the embroidered pillow of Ingres's image. His flat colors and bold outlines pervert his rival Manet's elegant brush-work and sophisticated emulations of Japanese prints,→Bathers as well as being in stark contrast to Ingres's fastidious polish. The result was a crude workmanlike manner.

Cezanne defiantly claimed he intentionally made the portrait to be refused by the Salon jury. He wished to demonstrate publicly a unique "tem-perament"—contemporary critics' code-word for artistic personality—combining painterly bravado and an anti-picturesque aesthetic that stood him apart from both conventional aca-demicism →Classicism and the pleasurable scenes of modern domesticity that characterized his early Impressionist comrades. It would take a few more years before he would settle down to experiment with a technique more closely de-rived—though still highly personal—from Im-pressionism's shorter, more fragmented brush-strokes →Impressionism and their outdoor practices.

D  *Portrait of the Painter Achille Emperaire*  1867–68
Oil on canvas  200 × 122 cm
Musée d'Orsay, Paris

Jean-Auguste-Dominique Ingres
*Napoleon on the Imperial Throne*  1806
Oil on canvas  259 × 162 cm
Musée de l'Armée, Paris

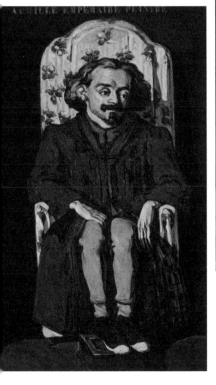

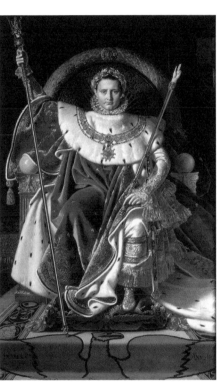

Now a suburb overrun by the urban sprawl of the port city of Marseille, in Cezanne's time L'Estaque was a residential and industrial town wedged between steep hills and the Mediterranean shore. The main Paris-Marseille train line from Aix emerged at L'Estaque via a tunnel through the rocks behind the village, and from which the tracks continued east to Marseille. Easily accessible from Aix, Cezanne spent time hiding in L'Estaque in order to evade police, who were trying to enforce the military draft in 1870 during the Franco-Prussian War. During this early stay, sharing for a time the early-Impressionist commitment to modern, including industrial landscapes, Cezanne made a few pictures showing the railway tracks emerging from the tunnel carved in the rock.

Perhaps in commemoration of Zola's visit to him during this time of draft dodging, Cezanne also made a strange and unique image said to have been designed for the cover of Madame Zola's sewing box.→p. 30 It shows a train against the background of a tileworks and the mining and metal refining company Rio Tinto on L'Estaque's industrial shore. The train can be distinguished by its vapors, trailing in the direction opposite from wind-wafted factory smoke as an indication of its speed. In Cezanne's later *Gulf of Marseilles as Seen from L'Estaque,*→p. 32 it is worth noting how houses and factories are generalized, with their chimneys and boxy shapes forming a visual counterpoint while framing the radically flat and

E  *Train and Factories à l'Estaque*  1869
   Cover for Mme. Zola's sewing box
   Watercolor and gouache  16 × 32 cm
   Musée Granet, Aix-en-Provence

shimmering blue water, closed off at the composition's top by the greyish-white limestone hills of the Frioul Islands off Marseille. It might be argued that these daring compositions laid the groundwork for other landscapes that seem to lead almost inexorably towards Cubism, and yet they retain a naturalism that younger artists moving more deliberately towards abstraction than Cezanne were to banish from their works by the 1890s.→ Kahn

E   *The Gulf of Marseilles Seen from L'Estaque*  *c.* 1885
    Oil on canvas  73 × 100 cm
    Metropolitan Museum of Art, New York
    H. O. Havemeyer Collection
    Bequest of Mrs. H. O. Havemeyer

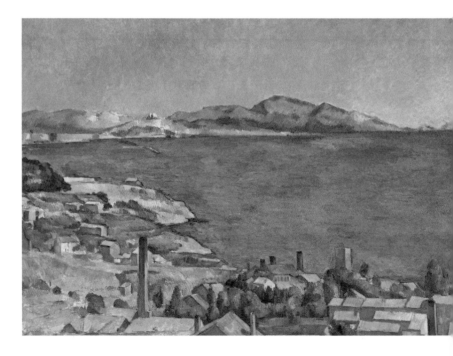

F  *Autumn Landscape* 1883–85
Oil on canvas  61 × 77 cm
Barnes Foundation, Philadelphia

More than the other progressive painters of his time, Cezanne left paintings with patches of canvas exposed, as well as numerous others that clearly appear to be unfinished. During the Renaissance, *non-finito* referred to a style in which forms appeared left to the viewer's imagination to complete, as an expression of a painter's ability to suggest through a spontaneous shorthand. This aesthetic was often encouraged by the challenge of the quickly drying plaster surfaces in the fresco medium that required *fa presto* (make quickly), i.e., rapid execution. In Impressionism, the light-colored ground with which canvases were prepared (a usage called *peinture claire* [light-colored painting]) served both as a source of luminosity and as spaces for the imagination to interact with the materials of art, the latter exposed by ostensible lack of finish.→ p. 34 Such paintings are certainly considered complete, and therefore finished, despite their *non-finito*. Many of Cezanne's works may be placed in this category.

Yet other examples by Cezanne take us further into the question of when a painting can be considered finished if significant areas are simply left uncovered. After leaving Paris more or less for good, Cezanne painted primarily for himself in relative isolation around Aix and at the Jas de Bouffan. Financially secure thanks to the inheritance from his father, he needed little support from either collectors or art dealers. Whatever his reputation, it was confined almost

F  *Still life with Apples*  1895–98
   Oil on canvas  68.5 × 92.7 cm
   Museum of Modern Art, New York
   Lillie P. Bliss Collection

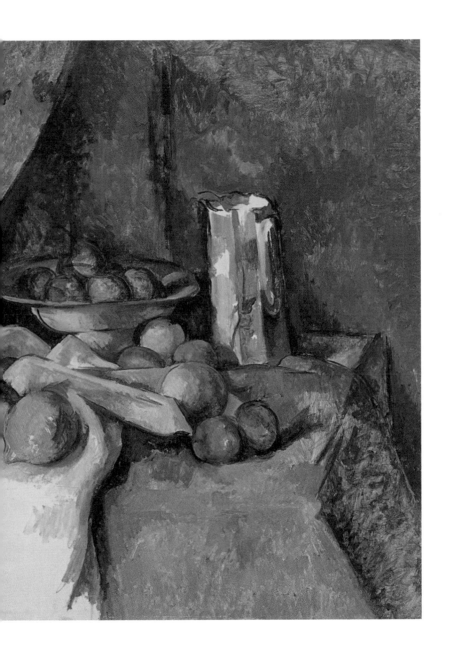

exclusively to artistic circles, until he was "discovered" in the 1890s by the dealer Ambroise Vollard. → Vollard

It can be said, then, that most of Cezanne's paintings were private and experimental; whether he brought them to conventional completion was a matter of choice. In some cases, he probably felt he had exhausted whatever pictorial problem he was confronting, or in others he may simply have lost interest, got distracted, or given up. Although pigment may not cover an entire painting's surface, as in Impressionist effects described in the paragraph above, Cezanne indeed left many paintings incomplete by any standards. → pp. 36/37 For today's viewers, such works are often prized for the insights they reveal regarding the artist's perceptions and working processes. Sometimes they may be considered like drawings in oils, sketches, or studies, on a par with drawings in other media or watercolors. → Water-based media In others, the unfinished look simply creates a casual, spontaneous effect, which one might consider a genre of its own, → p. 80 descended from the aesthetic of the fragment popular under Romanticism. It might be said that such paintings, despite not having been completed, were done as far as Cezanne could care, for he was "finished" with them for one reason or another.

G → **Gardanne**

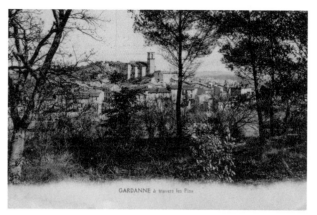

GARDANNE à travers les Pins

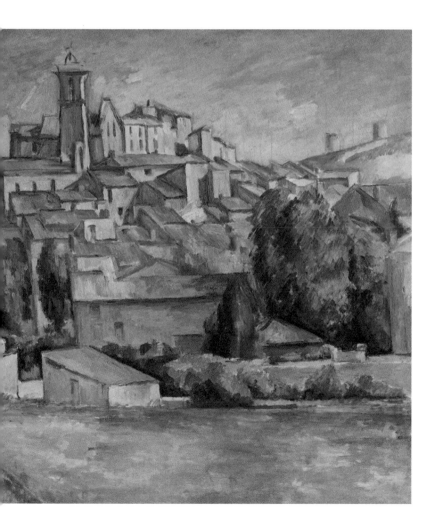

Cezanne worked at this village on the rail line south of Aix from the summer of 1885 to spring 1886, producing several views of its simple clustered buildings, crowned by the village church.→p. 40 Unlike his few more prosaic city views of Paris, their compact and powerful sculptural mass may have influenced Georges Braque's pictures of L'Estaque, which in 1908 the critic Louis Vauxelles famously dubbed "cubist." Two vertical views, both unfinished, suggest the challenge Cezanne faced to produce an authentic record of a picturesque view, yet one that embodied a harmonious and enduring unity.→pp. 40/41 His limited palette suggests the painter's interest in imaging solid forms through subtle tonal modulations produced by natural light. He varies the direction, touch, and color of his brushstrokes to indicate different textures and spatial relationships. With their internally varied, intricate, and fascinating counterpoint of verticals and horizontals, punctuated by slanted rooftops and interwoven with greenery, these exercises are among the most daunting and meticulously labored townscapes of Cezanne's career. Although there are few of them, these views contributed importantly to Cezanne's abstracting and unifying process.

H   *Madame Cezanne in a Red Armchair*  *c.* 1877
Oil on canvas  72.5 × 56 cm
Museum of Fine Arts, Boston
Bequest of Robert Treat Paine, 2nd

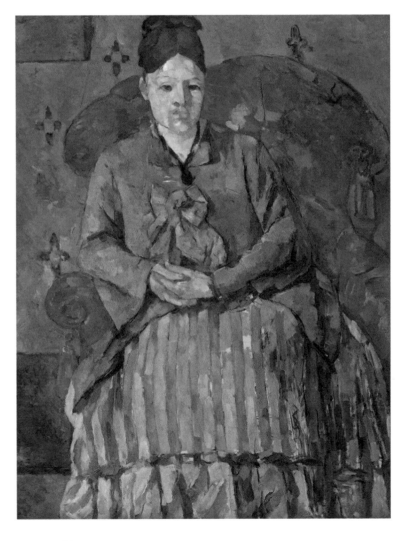

Cezanne's studio model, Marie-Hortense (best known by her second name) sat for her husband throughout his career. She bore Cezanne a son in 1872, but the painter kept their affair secret until his father discovered it in 1878. Despite his father's objections, they married in 1885. Although their relationship was strained at times, including the painter's complaints about her shopping trips to Paris, Cezanne's relatively impersonal representations of his wife are probably more due to his careful method and abstracting tendency than to powerful tensions between them. Following Madame Cezanne's portraits over time allows for many insights to Cezanne's gradual, and more or less orderly, stylistic development. From his Impressionist period during the 1870s, comes one of the most pleasing of these pictures, →p.44 thanks to its bright, rich colors, especially the red armchair and Hortense's fashionable blue-striped silk dress. Another feature of the composition is its tightly interlocking forms, like big pieces of a jigsaw puzzle, with the rectangular shape at the upper left-hand corner locking in the composition. Cezanne is often said to have coerced the Impressionist's color-based technique into producing the sensation of three-dimensional volume, →Ochre in contrast to the flattening effects of the Impressionists' fragmented forms. Here, however, the composition as a whole echoes Impressionism's so-called decorative planar patterning, while Madame Cezanne's hands stand out in contrast, as if the painter has modeled

them from clay. Then, in the lower part of the portrait, her dress reads as both delicate fabric and as a powerful block of form.

A later portrait of Madame Cezanne →p. 47 shows the painter's continuing approach to model-ing—her dress in particular—as if done by bare hands in a sculptor's medium. At the same time, Hortense's youthfully idealized head is a simply abstracted geometrical shape formed by curves and patches of astounding economy and subtle color variation, the result echoing clas-sical sculpture. Cezanne's ability to convey her individual features—although without particular psychological interest—and the work's quiet timelessness epitomizes his seminal modernity, anticipating portraits by the likes of Henri Matisse, Amadeo Modigliani, and sculptures by Constantin Brancusi.

H *Portrait of Madame Cezanne in a Red Dress* 1888–90
Oil on canvas 81 × 65 cm
Beyeler Foundation, Riehen/Basel

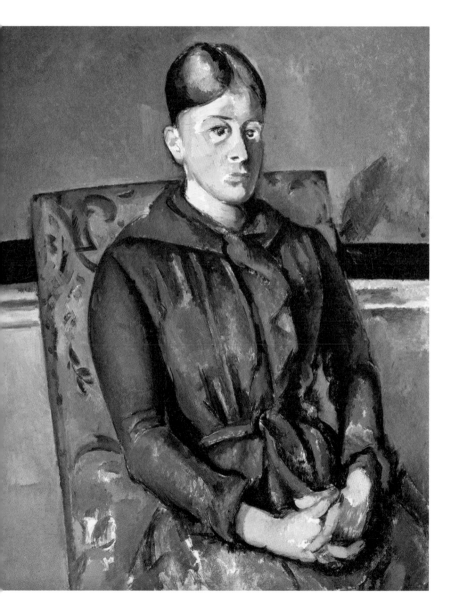

# I→ Impressionism

Following his friend Zola to Paris in 1860, then traveling there off and on from Aix during the following years, Cezanne encountered artists who would become his lifelong friends and cohorts, for example the budding Impressionists Claude Monet, Pierre-August Renoir, Camille Pissarro, and Armand Guillaumin. He also viewed works by the Realist painter Gustave Courbet, who was already established as an avant-garde rebel, and by the most notorious painter of the moment, Édouard Manet, already mentioned. →Bathers The radicalism of two latter in particular was considered both political and pictorial; both took their realistic themes from modern life, and they painted in styles that defied academic polish, as would all the Impressionists, following their lead.

While learning from both avant-garde painters, as part of a younger generation, Cezanne and his new friends sought to define themselves against their predecessors. They accepted that painting should be based on contemporary reality directly observed, but the majority now did so almost exclusively *en plein air* (out of doors), and in styles they personalized with even brighter colors and looser, more fragmented brushstrokes than their forebears. Within this shared commitment, however, the Impressionists diverged among themselves according to the slices of life they chose—Monet, Renoir, and Edgar Degas were oriented towards bourgeois leisure, while Pissarro and Guillaumin, towards

whom Cezanne would eventually gravitate, were sympathetic to more working-class themes, both rural and industrial. It was thanks to these relationships that Cezanne began to abandon his early literary and dramatic themes →Dramatic in favor of more settled and methodical, although still powerful representations of landscape. For example, at the first Impressionist exhibition in 1874, he showed a picture called *House of the Hanged Man, Auvers-sur-Oise* →p.51 which affects a gritty version of the short, dash-like brushstrokes current in Impressionist painting of the period. He also manages to overcome Impressionist flattening with a powerful sense of recession along the road that dives downhill at the composition's center.

Auvers is a town 27 kilometers northwest of Paris along the Oise River, a tributary of the Seine, where artists such as Charles-François Daubigny, and the homeopathic physician Doctor Paul Gachet resided. Gachet was an amateur artist who supported the Impressionists, especially Cezanne, Pissarro, and Guillaumin —outsiders like himself—by buying their pictures and sharing his printmaking press. (He is famous for his later relationship with Van Gogh.) One of Cezanne's best-known etchings is a portrait of Guillaumin signed with a hangman's noose to the upper left. Cezanne often worked side-by-side with either Pissarro or Guillaumin, and they occasionally copied each other's paintings. Cezanne's *Orchard, Côte Saint-Denis at*

1  *House of the Hanged Man, Auvers-sur-Oise*  c.1873
   Oil on canvas  355 × 66 cm
   Musée d'Orsay, Paris

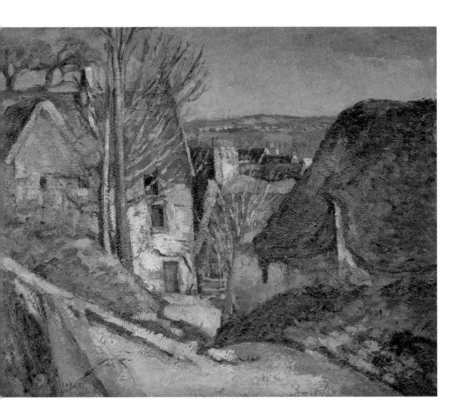

I  *Orchard, Côte Saint-Denis (Côte des Boeufs) at Pontoise* 1877
Oil on canvas  66 × 54.5 cm
Private Collection, USA

Camille Pissarro
*Côte Saint-Denis (Côte des Boeufs) at Pontoise* 1877
Oil on canvas
The National Gallery, London

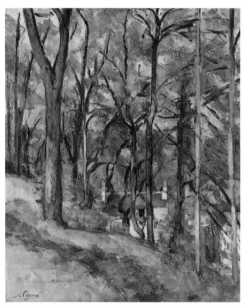

*Pontoise* may for example be compared with Pissarro's well-known painting of the same title and date. → p. 52

The Boston Museum of Fine Arts' *Turn in the Road, Auvers* → pp. 54/55 is one of the masterpieces Cezanne produced during this period. With all the freshness of Impressionist color and touch, despite its limited palette, the picture nevertheless implies a methodical process of observation, using the road to lead the eye, following each house shape by shape and lending their assembly a sense of interrelationship, a living harmony one often finds in ancient villages. The houses viewed through trees in the middle-ground seem to interweave with branches on the canvas surface, as encouraged by breaks in their limbs and the foliage. That is, colors, which the eye attributes to the houses, assert their presence in the same plane next to brush-strokes representing trunks and other parts of trees, even though we know there is distance between them. Preserving the freshness of direct observation, the painting nevertheless emerges as the painter's rational construct, a rendering in two dimensions clarified by the painter's intellectual perceptions. The latter are transcribed by a deliberate process of paint application extended over time in parallel, serial brushstrokes → Serial brushstrokes which occupy much of the surface rather than of the moment, as is so frequently said for more standard, ostensibly spontaneous Impressionist works like Monet's.

I *The Turn in the Road*
*(rue des Roches au Valhermeil, Auvers-sur-Oise)* *c.*1881
Oil on canvas 60 × 73 cm
Museum of Fine Arts, Boston
John T. Spaulding Bequest

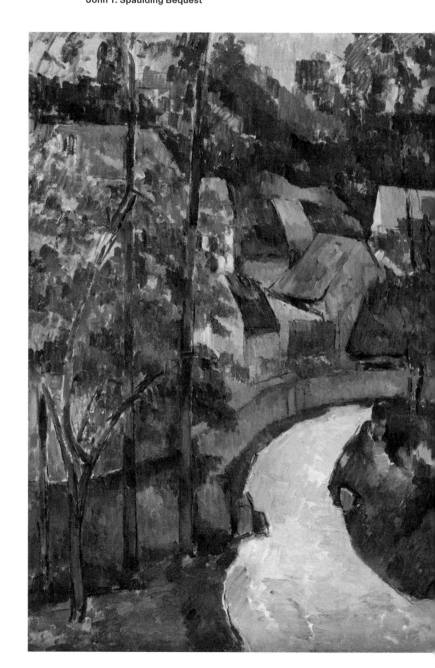

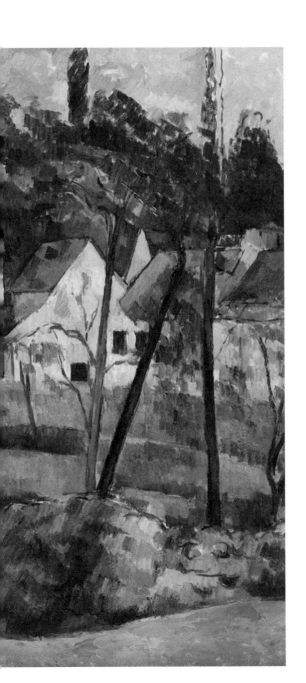

Works like *Turn in the Road* imply protracted observation and display a brushstroke system developed during what is sometimes called Cezanne's "apprenticeship" with the older Pissarro. (The latter tended to systematize his own application of brushstrokes, but he never used Cezanne's). Although Cezanne's commitment to the practice of painting directly from observation was ongoing, the self-consciousness and latent abstractions in examples such as *Turn in the Road* would lie at the heart of the mature style he developed when he moved definitively back to Aix-en-Provence.

J→ **Jas de Bouffan**

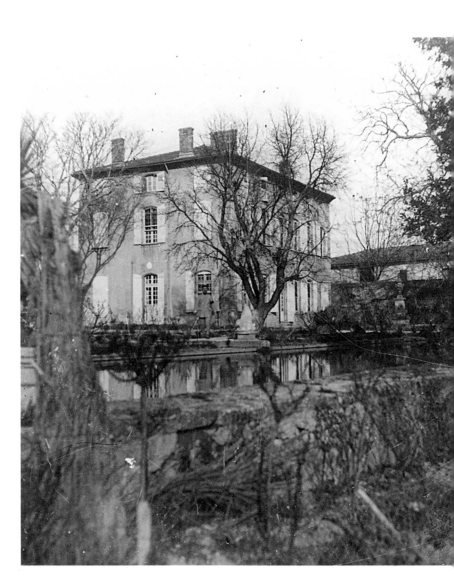

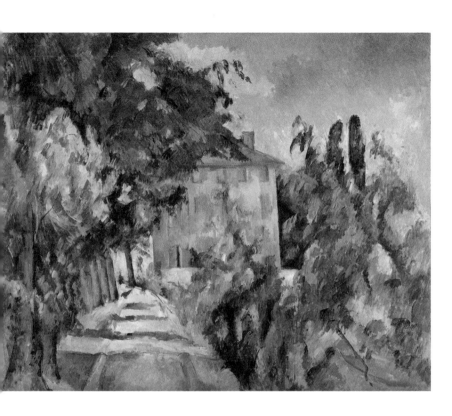

In 1859, Cezanne's father Louis-Auguste purchased the woods and vineyards comprising more than fourteen hectares (approximately 37 acres) known as the Jas de Bouffan.→ Aix-en-Provence (*Jas* is Provençal for a shelter, or in French a *gîte* normally for sheep). It came with an eighteenth-century *bastide* or manor-house made out of the local yellow stone, to which was attached a low-rise farmhouse.→ p. 59 Currently undergoing restoration by the city of Aix under the auspices of the *Société des Amis de Cezanne*, the main house still has figural murals that are among some of the painter's very earliest works. Alongside his traditional studies, young Paul attended the museum's drawing school; at home, he was allowed to use a small room on the top floor as a studio.

Following his father's death, the painter moved his small family to the residence permanently until it was sold in 1899, two years following his mother's death. Even more than the house itself, its appurtenances and grounds are often seen in the artist's paintings. The path from the main gate to the front door is still demarcated by a row of majestic chestnut trees on either side. To the right of the house is a basin with a statue of a lion at its corner, beyond which to the left stands an orangerie. From its sloping grounds, one could once look out over small farmhouses and fields towards the majestic Mount Sainte-Victoire, another frequent motif in Cezanne's oeuvre, and which he began painting as soon as he moved in.→ Mount Sainte-Victoire

Kahn was a poet and critic associated with Symbolism, which was primarily a literary movement, but whose leader in visual art was Paul Gauguin. Much like Cezanne, Gauguin had begun as an Impressionist, which he eventually abandoned in favor of overtly subjective representations he declared to be taken from memory and dreaming before nature with closed eyes, which he opposed to Impressionism's culture of direct observation. Kahn neatly defined the opposition between Symbolist painting and Impressionism stating that "[T]he aim of our art is not to subjectify the objective (nature seen through a temperament), but to objectify the subjective (the externalization of the Idea)."[4] The first part of the statement paraphrased a definition of art—a corner of nature seen through a temperament—proffered by Émile Zola, →Zola, Émile who was referring to what would become Impressionism. Kahn turned the definition on its head to emphasize the Idea—the mental, subjective source of artistic imagery rather than external reality—which painters rendered as an external, physical object. Cezanne fits either definition.

Indeed, Gauguin and many of his Symbolist followers admired Cezanne; →p. 63 Gauguin described him glowingly as a great mystic, that is, emphasizing his interior spiritual experience as if to co-opt him to Symbolist ideas. Indeed, to Cezanne's annoyance, Gauguin also often adopted the serial brushstroke technique Cezanne had developed when both artists still

K    Maurice Denis
     *Homage to Cezanne* 1900
     Oil on canvas 180 × 240 cm
     Musée d'Orsay, Paris

frequented the Impressionists and which is specifically characteristic of so many of Cezanne's works.→Serial Brushstrokes There can be no doubt that this technique, combined with Cezanne's distortions of forms and compressions of space, place Cezanne among painters like Gauguin who might be said to "reprocess" nature through a creative intellect that relies in part on memory. At the time, Impressionism was being attacked as mere copying, like photography but with color. The next generation of artists, with whom Cezanne is often classified as a Post-Impressionist, disdained the so-called accurate and naïve naturalism of Impressionism. They saw Cezanne as one of them, even though he himself insisted on working directly from nature (as did Van Gogh). So while Cezanne's paintings certainly develop in the direction of Symbolism, they defy simplistic categories and reveal the futility of drawing firm lines between one movement and another. There was always a subjective element to Impressionism, as the very word "impression" implies, but, in Cezanne's work, the eyes-wide-open observation of nature remained where his paintings began, even if, compared to the reputations of his Impressionist cohorts, he sought a more internalized response to nature as the ultimate stimulus rather than mere accurate descriptions of its visible externality.

∟→ **Legacy**

Cezanne's stylistic simplifications and distortions, which to some suggest a fusion of multiple viewpoints →Philosophy led directly to Cubism.→Gardanne Practically unknown except among his immediate circle of friends and former cohorts until the 1890s,→Vollard, Ambroise later exhibitions of his work thrilled younger artists, such as Georges Braque and Pablo Picasso, who built on Cezanne's later, energized, and increasingly abstracted work in particular →p. 68—combined with other sources such as African and Iberian sculpture—to develop the first modern forms of truly abstracted art.

Cezanne's legacy did not stop there, nor was it always positive. For example, during the first quarter of the twentieth century it was understood as a classicizing alternative to Impressionism, by then associated negatively with extremes of Romantic emotionalism, feminine hyperesthesia, and messy democratic disorder. It was true that in his provincial environment, Cezanne had become politically conservative, including anti-Dreyfusard, hence deeply opposed to his old friend Zola, whose famous open letter "*J'Accuse!*" defended the Jewish army captain Alfred Dreyfus against false and anti-Semitic accusations of spying for France's German enemies. Claude Monet, far and away the best-known Impressionist, also supported the innocent Dreyfus and was associated with the liberal-left politics of his close friend Georges Clemenceau. As Prime Minister, Clemenceau led France to victory in World War I (with the help

of the Allies of course), but he soon fell out of favor. Conservative, xenophobic, and anti-Semitic parties sought a "Return to Order"; similarly, in art they favored a classical tradition with which they associated Cezanne after his death. → Classicism Artists including Fernand Léger, the Purists (Amédée Ozenfant and Charles-Édouard Jean-neret, better known as Le Corbusier), as well as Jean Cocteau, argued that Cezanne upheld the true French tradition, which they now saw as heir to Greco-Roman antiquity, with its echoes of stoic masculinity. Supporters of Impression-ism had been claiming that the national tradition was embodied by the Rococo painter Antoine Watteau and the renowned Romantic colorist, Eugène Delacroix. Art became the tool of a virulently nationalist politics on both liberal and conservative sides.

In another, more artistic legacy, in addition to the path he opened towards abstract art, Cezanne's method of transcribing his direct optical experience using color modulations to create space and forms, if it can be codified, became entrenched in art teaching as the twentieth century wore on. More than anywhere else, it was exemplified by the school set up in Aix-en-Provence by the German painter Leo Marchutz, whose admiration of Cezanne was boundless.

Many still consider Cezanne the "father" of modern art, especially those who favor what appears to be his relatively cerebral orientation

L  *Mount Sainte-Victoire, Seen from Les Lauves*  1902–04
Oil on canvas  60 × 72 cm
Kunstmuseum Basel

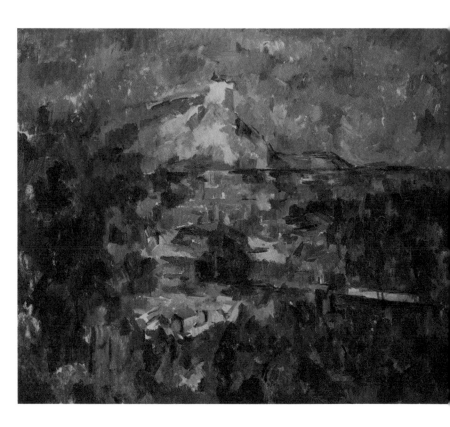

to the creative process, compared to the ostensibly more instinctive and spontaneous Monet. It is debatable, however, to what extent Cezanne's art is in fact primarily intellectual, since his claim was to "realize" his sensations, sensations therefore coming first, and directly from his experiences of nature. Moreover, with Abstract Expressionism, Pop Art, Installation and Performance Art, the direct and immediate appeal to the bodily senses became paramount, and is still an important aspect of the contemporary. Philosophically speaking,→ Philosophy Cezanne's painting can just as easily be associated with Impressionism's supposed reliance on and appeal to direct sensation and gratification, aspects rejected as less serious than the "classicism" ascribed to him by the astringent requirements of the political "Return to Order." By respecting truths that can be found in both trends, Cezanne may be said to have attained a culmination point with far-reaching consequences. Today, it is precisely Cezanne's transcendence of easy cliché and narrow scholarly classification that continues to command attention, making him simply, and grandly, a sublime artist who defies categorization no matter what our current preferences.

Named for the Gallo-Roman victory of 102 BCE over invading Germanic tribes, the Mountain of Sacred Victory—to translate its name literally—was a symbol of Provençal independence and identity. Cezanne hiked along its pathways and was no doubt aware, thanks to his friend Marion, → Aix-en-Provence that on its slopes could be found prehistoric remains, in addition to evidence of its ancient geological origins. The mountain was a dominant motif in Cezanne's landscapes, and as a result has become as deeply identified with his oeuvre as it is with Provence. Although Cezanne painted its limestone mass from a variety of viewpoints—the Jas de Bouffan, the Bellevue Hill, the Tholonet Road, and finally from his studio on the Lauves Hill—whether seen through trees or across the Arc River's agricultural plain, it almost always closes off the landscape, suggesting the territory's isolation from the rest of the world and its self-sufficiency. In one of his most majestic views,→ pp. 72/73 done from his sister's house, Cezanne makes the landscape seem distanced; there is little fore-ground access afforded the viewer, as if looking upon a world that exists independent of the passage of time and human presence. Simpli-fications of farmhouses—inevitable signs of human habitation—and especially of the railway viaduct crossing the valley as if it were a Roman aqueduct, enhance the sense of enduring permanence. Such views call forth comparisons to the seventeenth-century painter Nicolas Poussin, whose overtly classicizing style Cezanne

M  *Mount Sainte-Victoire and the
   Viaduct of the Arc River Valley* 1882–85
   Oil on canvas  65.4 × 81.6 cm
   The Metropolitan Museum of Art
   H. O. Havemeyer Collection
   Bequest of Mrs. H. O. Havemeyer  1929

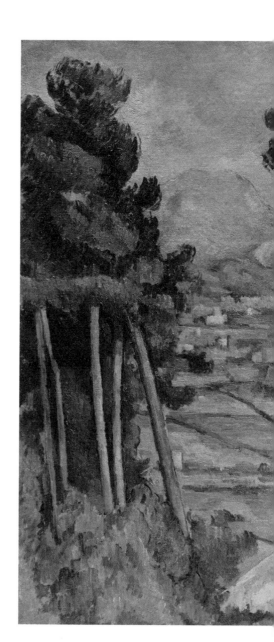

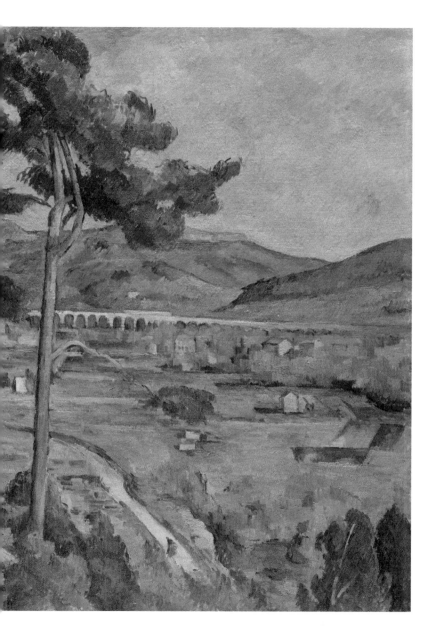

admired and was a prime example of those he wished to update through greater naturalism.[5] And yet, in such broad views, trees are almost always located to one side in order to afford the viewer a grand prospect. Here the solitary Mediterranean pine in the composition's center is an unusual obstacle as well as a powerful design element. Cezanne challenges convention and seems to dare his audience to think differently.

N → **Nature**

During a dialogue with the painter Émile Bernard, Cezanne contrasted his aims to those of past masters: "They created a picture [tableau]; we are attempting a piece [morceau] of nature."[6] Although doubts are often raised about the reliability of statements Cezanne is supposed to have made during meetings or interviews with friends or journalists, this one raises questions worth considering. (Bernard is one source of the famously misleading and reductive formula that, according to Cezanne, all of nature can be reduced to the "sphere, the cylinder, and the cone.") Bernard had worked in Brittany along-side Gauguin,[→Kahn, Gustave] but, even more than Gauguin, he became a devotee of Cezanne, about whom he published *Conversations,* based on his extended visits to the painter in 1904 (*Mercure de France*, June 1, 1921). An important theme of their dialogue was the paradoxical duality of art rooted in the tension between a method based on direct and constant observation of nature, as in Impressionist practice, and the subjectivity of the artist's way of seeing, as emphasized by the following generation, like Gauguin, who insisted on memory and fantasy rather than accurate description.

Cezanne's claim for "a piece of nature" regarding his aim for art followed Bernard's reminder that artists traditionally used line, composition, and modeling for their pictures. Cezanne seemed to be making a distinction between the conventional artifices of such pictures and the

real. Yet he did not deny differences between art and nature, and he asserted, as cited by Bernard, that every artist must have an *optics*, by which he meant an organizing function to vision, which each artist finds in nature, nature being perfect, and to which the painter must therefore always defer.[7]

The contradictions among these statements suggest the complexity of the task Cezanne set for himself. To make "a piece of nature" without employing artifice, that is, through means derived solely from nature, appears on the one hand to eliminate the artist's creative performance, while admitting on the other that each artist has their own way of seeing. Moreover, nature, especially the landscapes for which he became most famous, is living matter, ever changing over time as evolutionary theory was showing. He raises the question, then, of how an object produced from inert materials could possibly act as if alive. At times, Cezanne invoked quasi-religious language to suggest how nature could be the source of creativity, as if such forces were acting through the artist.

It is impossible of course to deny that viewers of artworks project upon them ideas derived from their own experience. Art may not *express*, therefore, as if it can talk or feel like a living creature, but it can be formed to elicit responses from viewers as if the picture had agency to act upon them—as if art has a performative

being of its own. In claiming to attempt a piece of nature, Cezanne demanded of himself art that could act as if his own intelligent powers of representation made nature reveal itself more actively, yet without artifice, to those who might encounter it through his pictures.→ Philosophy Or put more simply, make art into nature itself, but more so. Gustave Courbet is said to have claimed "I even make stones think."[8] Cezanne was less direct and more discreet, declaring: "The landscape thinks itself in me and I am its consciousness."[9]

# Ochre: Cezanne's Use of Color

O  *Self-Portrait  c.* 1877
Oil on canvas  61 × 47 cm
Phillips Collection, Washington, D.C.

*Self-Portrait in a Straw Hat*  1878–79
Oil on canvas  34 × 26 cm
Museum of Modern Art, New York
The William S. Paley Collection

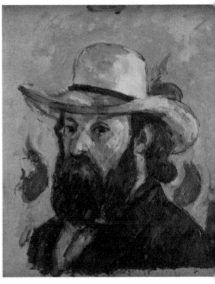

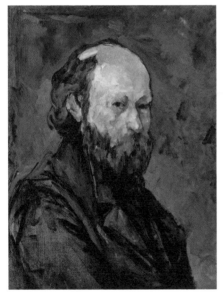

Pigments referred to as ochres vary from yellow through orange to reddish brown and are derived from clay permeated with ferrous oxide. True "earth" colors, they might be said to have been used by Cezanne as an aspect of making art into nature itself.→ Nature More generally speaking, Cezanne's painting follows the principle underlying Impressionism, namely that we perceive forms through color: lines do not exist in nature, it is through color that nature lives in human consciousness. Yet, unlike the Impressionist tendency to represent merely the surface of objects, Cezanne set out to use color to express mass and volume, aspects of reality we learn to derive from simple looking through experiences that begin in early childhood and which therefore live in human memory and inform all future experience, as well.→ Philosophy Cezanne avoided the fragmentation produced by the Impressionist brushstroke, attempting to fuse patches of color subtly modulated (he preferred this word to the traditional term, modeling) to produce a sense of varied surfaces or their situation and interrelation in space. The continuity of his serial brushstroke system → Serial Brushstrokes attempts to synthesize Impressionism's precise but multiple points of perception with the sense of development and continuity underlying natural processes, even if it cannot directly emulate those processes themselves.

An excellent example of this effort can be found in a self-portrait dating from about 1877.→ p. 80

This and other paintings, like Boston's *Turn in the Road*,→p.54 mark an important phase when Cezanne was searching for a systematic way to deploy Impressionist brushstrokes to achieve the modulating effects he considered both more true to nature and to human understanding of it than the standard, surface-bound Impressionism. The self-portrait's nearly monochromatic palette bears witness to Cezanne's concentration on producing the illusion of volume through subtle color variations alone. The portrait also illustrates another important feature of Cezanne's technique, namely his refusal to use line to produce the effect of contour. At the bridge of the nose and the arc of the left eye, he uses a darker color to imply the absence of form where the nose-shape ends. There may be the suggestion of a shadow and even the emulation of a line, but in fact it is a patch of paint shaped in way to produce both sensations rather than traditional line associated with drawing.

In many pictures, as on the foliage of the central pine in *Mount Sainte-Victoire and the Viaduct of the Arc River Valley*,→p.72 deftly sketched brushstrokes in blue-black, a recessive color, suggest the limits of the forms to which they refer. At the same time, they can be read independently, as if tracing the painter's thought rather than descriptively outlining foliage. In a related manner, Cezanne also used touches of darker color to perform the function of outline

on still life objects,→p.114 but in a tentative and animated manner far less defining than traditional contour and which implies its object's spatial plenitude. Using color to suggest rather than line to define form, Cezanne emulated the body's responses to the eye's color-based perceptions (not that they are separable). Through a naturalistic technique, that is, one based on actual experience rather than on formulas, Cezanne could imagine bringing the viewer closer to nature and therefore to the truth in nature to which he believed the artist must always defer.

P→ **Philosophy**

Henri Bergson and Maurice Merleau-Ponty are two of France's greatest modern philosophers. In their discussions whether about Cezanne himself (Merleau-Ponty) or with implications for Cezanne (Bergson), Merleau-Ponty was pre-occupied with time, and Bergson with space.

In 1945, Merleau-Ponty published one of the most perceptive essays on Cezanne ever written under the title "Cezanne's Doubt." (He continued to pursue the topic in *L'Œil et l'es-prit*, 1961.) Merleau-Ponty was a proponent of phenomenology, which focuses on the relation-ship between individual consciousness and the objects of its experience, an experience-based refinement of the existential question of "be-ing in the world." For Merleau-Ponty, Cezanne's painting embodies the problem evoked in the artist's conversation with Émile Bernard,→ Nature namely the relationship between subjective perception and external reality in the production of the artwork.

Merleau-Ponty's view was that Cezanne's painting enacts the process through which the individual apprehends the world through the bodily senses and thereby acquires knowledge of its own situation in the world. Although it is still convenient to use separate terms, Merleau-Ponty believed that mind and body cannot be separated. Vision is informed by touch begin-ning in infancy. Touch and movement educate the infant to the world's spatiality. Memories

of these early and constantly renewed experiences inform vision, so that when looking from a distance the mind-body recalls experiences of surfaces and spatial relationships even if it cannot be present at the place where they occur. It is as if the eye brings the rest of the body with it when contemplating its surroundings; there can be a "virtual" presence in the spaces that are not only beyond the body or which are momentarily hidden by objects.

It is impossible to perceive without interpretation, in which memory is a necessary participant. Merleau-Ponty argues that in Cezanne's paintings, space and forms that occupy it are represented not through the academy's mathematical one-point perspective but through what he called "lived" perspective. Memories of the body's mobility and experiences of touch inform Cezanne's depiction of the world from what may appear to be a conscious fusion of multiple viewpoints, but which according to Merleau-Ponty is a single unified perception rooted in an instinctive understanding grounded in memory. Two rather different examples of this phenomenon may be found in still life compositions such as *Still Life with Commode* → Textiles and Montagne Sainte-Victoire. → Mount Sainte-Victoire

A philosopher of Cezanne's own time with whom he is sometimes associated is Henri Bergson. He coined the term *élan vital* (life drive or vital force) in order to explain what produces change

and natural development through time, picking up philosophically on Charles Darwin's theory of evolution. Bergson notes that although evolution can be described scientifically, its cause remains a mystery, accessible, he argues, only through philosophy based not on science but on intuition. His explanation (picked up by later philosophers including Merleau-Ponty, who much admired Bergson) was that memory, embedded in the body, is key. Continuity, or development over time is a function of memory. Representations cannot not reproduce the phenomenon of continuity, which is at the heart of being; they can only represent various and multiple static stages. Thanks to memories of successive stages leading up to a current perception, consciousness projects the experience of its own continuity on to the present and its objects. It is consciousness, not objects or representations, that produces continuity. Science can only describe effects; philosophy, through knowledge found within the self—which Bergson calls intuition—reveals the life force underlying the continuity of experience.

The challenge facing Cezanne was therefore to represent the experience of nature lived through time and space by means of a medium that appears to freeze time and is limited to a single view. Cezanne encourages the viewer to intuit nature's persistence through time from his artistic representations, even though they are static. He does so both through the sense of

permanence he is able to evoke thanks to simpli-
fications that seem to eliminate contingent
detail, but also by way of his successive brush-
strokes, which encourage the viewer to experi-
ence the artist's processes through time. I call
this Cezanne's "seriality". →Serial Brushstrokes

Cezanne's paintings often lead to extended
viewing; serious admirers can spend many long
minutes before one of them or another. Although
there is no evidence that Cezanne knew
Bergson's ideas, it nevertheless seems possible
that by "a piece of nature," →Nature he aimed
somehow to convey through art an intuition of
the driving force Bergson later named *élan vital*.
Whether or not there are influences or parallels
with either philosopher, that Cezanne's painting
elicits comparisons to them, and that there
continue to be philosophical responses to his art,
testify to the seriousness with which his paint-
ing demands to be regarded.[10]

Q→ **Quarry**

Q   *Rocks at Bibémus* 1895–1900
Watercolor and graphite on paper 47.5 × 41.5 cm
Staatliche Graphische Sammlung, Munich
Bequest of Woty and Theodor Werner

*Le Château Noir* 1900–04
Oil on canvas 74 × 96.5 cm
National Gallery of Art, Washington, D.C.
Gift of Eugene and Agnes Ernst Meyer

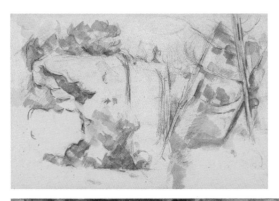

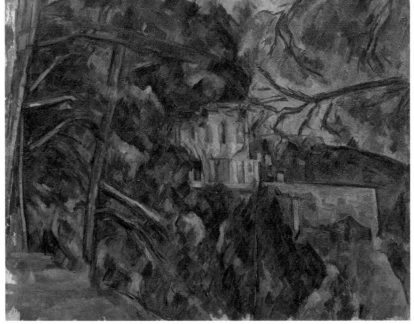

The quarry at Bibémus and the Château Noir on opposite sides of the road east out of Aix towards the village of Le Tholonet, were among the most important for Cézanne's more complex and compelling landscapes. A path led from one site to the other. Cezanne was obviously fascinated by the rocky terrain characterizing both.→ p. 90 Both afforded a contrast with the panoramic views that featured Montagne Sainte-Victoire → Mount Sainte-Victoire in the background thanks to their more intimate focus. At the Château Noir there were outcrops of grey limestone; Bibémus was where stonecutters mined *molasse*, the yellow-ochre sandstone characteristic of old Aix.

Cezanne kept equipment in a small shelter he rented near the quarry in order to avoid carrying everything with him in the carriage that took him to and from home. At the Château Noir, the owner afforded him a similar privilege. Paintings of the quarry in particular bore witness to the labor of man that carved out building blocks from nature, while he also traced the delicately varying surfaces of the rock faces left behind. One can't help but wonder if Cezanne consciously understood the act of quarrying as a parallel to his own attempt to chisel out a "piece of nature" from the whole.→ Nature Or might it be said that by responding to forms in nature, he was endowing them with the ability to perform (or releasing them from their static inability), allowing to them a kind of life he hoped to emulate through his pictures.

The Château Noir's extensive grounds are situated in a clearing atop a rugged stony incline above the road. With its pointed arches, the villa displayed a curious Provençal gothic revival style. From its high perch, Cezanne painted some of his most complex yet successfully balanced compositions combining rocks and vegetation.<sup>→p.90</sup> As depicted in one of the painter's more fascinating and complexly interlocking compositions, the property had an old well and the remnants of a mill.<sup>→p.93</sup> Following the sale of the Jas de Bouffan in 1899, Cezanne tried unsuccessfully to buy the Château Noir, after which he acquired the property on which he established his studio on the Lauves Hill. →Aix-en-Provence

Away from the road and surrounded by sweet-smelling pine woods, both the quarry and the Château Noir's rocky hill were already overgrown with trees in Cezanne's time. Their complex geometries and intermixing of colors must have delighted the painter as well as the quarry's evocation, like Mount Sainte-Victoire, →Mount Sainte-Victoire of the region's ancient and unique geology. As in his townscapes of Gardanne, →Gardanne Cezanne seems to have been drawn to the intricate formations offering the opportunity to create an interplay of planes and tautly interlocked compositional patterns and that must have called out to him with an uncanny sense of harmony and life. There is perhaps no more powerful example of this fruitful convergence of the painter's pictorial interests and subject

Q  *Millstone in the Park of the Château Noir*  1892–94
Oil on canvas  73 × 92 cm
Philadelphia Museum of Art
Mr. and Mrs. Carol S. Tyson, Jr. Collection

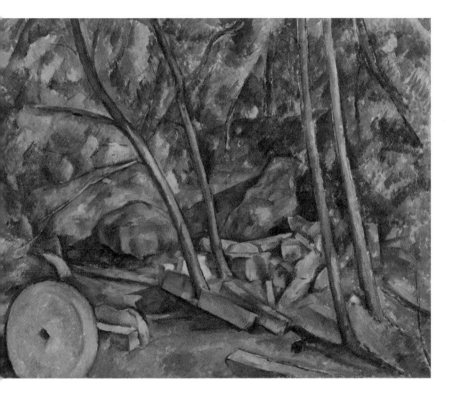

Q   *The Quarry of Bibémus*  c.1895
    Oil on canvas  65 × 80 cm
    Museum Folkwang, Essen

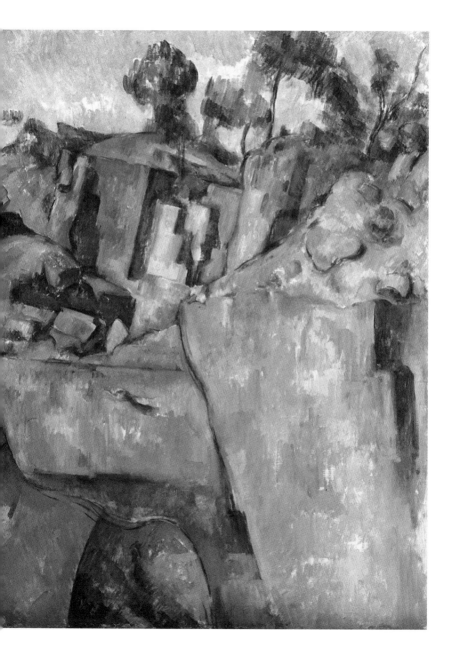

matter close to Cezanne's sense of artistic identity than the painting *The Quarry of Bibémus* of circa 1895 →pp. 94/95 where the artist's vision seems to emanate from deep within the earth.

The father of modern Cezanne and Impressionism studies, John Rewald emigrated from Germany to New York in 1941, bringing with him the rigor of European scholarship and the sensibility of a fine observer. His interest in Cezanne grew out of his 1936 Sorbonne dissertation on the relationship between Cezanne and Zola.→ Zola, Émile His articles, his biographical monograph, and his catalogue raisonné of Cezanne's works laid the groundwork for all future Cezanne studies. In addition to gathering Cezanne's letters, a key to Rewald's method was to locate and photograph sites painted by Cezanne. These records allowed him and future scholars to group Cezanne's mostly undated and unsigned paintings, watercolors, and drawings in order to attempt a chronology and ascertain authenticity.

Rewald's primarily archival approach was coupled with formal analysis and assessments of quality based on his long experience of Cezanne's life and art. An important contribution to a deeper understanding of Cezanne's achievement was Fritz Novotny's *Cezanne and the End of Scientific Perspective* (1938), which built on Rewald's findings to discuss Cezanne's transformations of what photographs seemed to establish as "reality." As noted above,→ Philosophy however, the philosopher Merleau-Ponty implicitly questioned photographic reality by revealing how we respond bodily to our environment and attributing Cezanne's so-called transformations

to "lived perspective," for which one might claim even greater authenticity than the camera could provide.

The American art historian Meyer Schapiro, in a 1952 monograph and in a classic article again in 1968 entitled "The Apples of Cezanne: An Essay on the Meaning of Still life", used Cezanne's classical education, as evidenced in early letters and the painter's youthful poetic compositions, to reveal attitudes towards natural forms such as apples, and by extension nature, as objects of a quasi-yet-repressed erotic desire. Schapiro's disciple, Theodore Reff, subsequently produced a series of articles, one of which ("Cezanne's Constructive Stroke," *The Art Quarterly*, 1962) brought formal and psychological analysis together to suggest underlying motivations in the development of Cezanne's style. Richard Shiff's *Cezanne and the End of Impressionism* (1984) demonstrated the overlap between Impressionism and Symbolism in both theory and technique, showing how Cezanne transcended both categories. In a groundbreaking interdisciplinary study, Nina Athanassoglou Kallmyer (*Cezanne and Provence: The Painter in His Culture*, 2003) stressed the relationship of Cezanne's paintings both to the physical land and geological history of Provence as well as to the region's social and political conservatism. More recently, Faya Causey has probed the depths of Cezanne's association with the intellectual and scientific milieu of his time.

A key feature of Cezanne's style, developed in the later 1870s and carried through to varying degrees for the rest of his career, are the parallel brushstrokes that make up patches of color within his compositions. For example, in *Still life with Apples*,[→p.106] Cezanne juxtaposed individually articulated strokes of color methodically as if to mark each instant of perception. In the process of constructing—hence Theodore Reff's term "constructive stroke"[→Rewald, John]—each form is labored and calculated. Shifting this term to become "serial" brushstrokes (rather than or in addition to "constructive") places the emphasis on elapsing time, almost like the ticking of a clock. Each passage—in this case, each apple—appears formed sequentially, as if scanned bit by bit or stroke by stroke, as opposed to the instantaneity associated with Impressionism's rapid touches. In *Still life with Apples*, the sense of time is enhanced by a composition which, as in *Turn in the Road*,[→pp.54/55] leads the eye from one object-form to the next. Shifts in color from one apple to another might even suggest the ripening of fruit over time.

Serial brushstrokes make a record of multiple instants within a prolonged process of observation. At times, they appear obsessive. In later and more complex compositions,[→p.34] patches made up of serial brushstrokes are sketched more freely and are often connected to one another. In such compositions, the patches themselves are assembled over the time it takes

the viewer to perceive them as a solidly crafted and unified surrogate for nature. The patches may even seem to be applied randomly, as the painter's eye is caught by particular perceptions. The serial brushstroke technique answers to the criticism made by the following generation that Impressionism was anecdotal and that it missed the underlying truth of nature's continuity through time, during which, whether over days, seasons, or eons it is nevertheless always changing. Both Claude Monet, by doing paintings in series in his later years, and Cezanne, through the serial brushstrokes that became a trademark of his style, even when painting quickly, faced the challenge of expressing the continuous and evolutionary essence of nature.

Cezanne's system introduced a profound ambiguity for which it formed a paradigm. While each parallel stroke seems to repress its object's plenitude, in *Still Life with Apples* the sheer force of the painter's rich colors struggles to express it. In *Turn of the Road*, the treatment of patches by parallel brushstrokes and their ostensibly piecemeal assembly produces both a naïvely flat, cardboard-like assemblage at the same time as it enables the eye to process the elaboration of space sequentially. The productive tension, in other words, between the intellectual and the sensuous elements deconstructs what in our experience is an otherwise unconscious and completely resolved partnership between mind and body—if the two can

even be isolated as separate functions. That serial brushstrokes are also constructive, might be said to produce a unique articulation of the inseparability of space and time. As the painter Wassily Kandinsky, the beginning of whose career overlapped with the end of Cezanne's, wrote: "He made a living thing out of a teacup. To be more precise, he realized the existence of a being in this cup. He raised the *nature morte* to a height where the exteriorly 'dead' object becomes inwardly alive."

T→ **Textiles**

Nowhere is the play between illusion and artifice more visible than in paintings in which so many generally white tablecloths are treated as free-form settings for the objects placed upon them. They are among the keys to Cezanne's unrivalled greatness as a purveyor of still lifes. An early example of Cezanne's deliberate ambiguities is *Still Life with Flask, Glass, and Jug.*→p.109 Until Cezanne, even the most fancifully placed tablecloths had been painted logically, that is, so that their folds and pleats make sense to the eye. By contrast, to the left in Cezanne's picture the cloth is bunched up in indecipherable folds; to the right, a dark triangle juts upward from the painting's lower edge, with the tablecloth stretched thinly over it to a surface juxtaposed at an angle and which appears to float, minus the support (a table leg?) one would expect to find within the triangle. Are we at the table's edge, a corner, or is does the table have a fold-out panel? One suspects, indeed, that Cezanne saw a parallel between the tablecloths and the painting canvas cloth as surfaces over which the artist plays with form and through which they themselves create and participate in the pictorial action. Spatial relationships seem topsy-turvy, with motifs from the wallpaper—another flat surface covering—projecting outward, defying their position as print upon the wall. (The same wallpaper here as in →p.44 shows the two paintings to be proximate in date.) And in a further contradictory reference to the art of the past, the knife, rather than typically creating

T *Still life with Apples* c.1878
Oil on canvas 19 × 26.7 cm
Fitzwilliam Museum, Cambridge, U.K.
Lent by the Provost and Fellows of King's College
Keynes collection

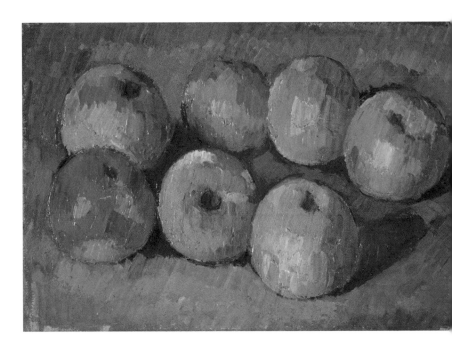

the illusion of sticking out into the viewer's space—a common feature of old-master still life—is completely imbricated within the texture of the cloth.

Revived in the second half of the nineteenth century, still life was considered a paradigm for artistic composition: the artist's arbitrary arrangement of forms prior to being painted constitutes a work of pictorial composition in itself. In a number of pictures such as *Still Life with Commode*,→ pp. 110/111 the table seems tipped slightly to the left and toward the viewer, in what is perhaps an example of Merleau-Ponty's lived perspective.→ Philosophy Its edges, visible on either side of the wildly capricious tablecloth, appear disconnected or make the table appear possibly warped. Objects are posed so deliberately that they seem like soldiers rigidly at attention, viewed dead frontally, yet one can see the openings at their top, as if from above, and on the tipped table top they stand precariously, as if they could easily slide forward. These tensions and ambiguities are complemented by another way of reading them, that is, as if they are pasted to the picture's surface, either naïvely or in what will come to be known as a collage. The commode in the background compresses space forward and yet at the bottom right disappears confusingly, blending away to merge floor and furniture. To the left is wallpaper, below which it is hard to tell whether we are looking at the opening to a hallway or the wall directly behind

the commode. These are effects of pictorial wit that distinguish art from nature. It is ironic that, by engaging the eye in such a constant exercise of interpretation and mystery, the devices of art produce the effect of a living, activated nature despite the term *nature morte* (dead nature)—which is the French term for the still-life genre.

T  *Still Life with Flask, Glass, and Jug*  c. 1877
Oil on canvas  46 × 55 cm
Solomon R. Guggenheim Museum, New York
Thannhauser Collection
Gift of Justin K. Thannhauser

Willem Claesz. Heda
*Still Life with Ham*  1640
Oil on wood  89 × 60 cm
Museum Boijmans Van Beuningen, Rotterdam

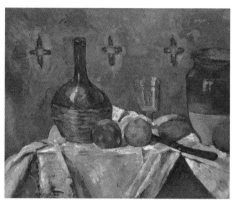

T  *Still Life with Commode*  1887–88
Oil on canvas  71.5 × 90 cm
Bayerische Staatsgemäldesammlungen, Munich
Tschudi-Spende

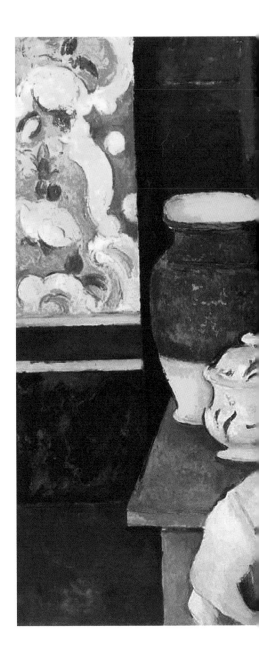

U → **Uncanny**

Cezanne's distortions and other forms of artifice often have the effect of defamiliarizing the most ordinary scenes, causing the viewer to pay them new attention. All art focuses attention on its subject matter, of course, but Cezanne's choices and distinct pictorial vocabulary create a poetic intensity of heightened and sometimes disconcerting vision even when focused on the most ordinary themes or scenes. In an early still life painted for his friend Zola,→ Zola, Émile the objects Cezanne chose to include produce a sinister, perhaps mocking effect.→ p. 117 The black, handless clock, its placement against a mirror, crowding the table in front of it, garish colors, and the monstrous, red, lip-smacking abalone shell, present a bizarre combination that implies and yet defies precise symbolic interpretation. Other paintings, such as Cezanne's monumental *Cardplayers*,→ p. 117 project the most familiar scene into an uncanny sphere of timelessness and gravity. A simple game observed at a local café assumes potential as an allegory for life itself, its players, whom Cezanne studied individually, rendered with the weighty presence of Renaissance painting and the sobriety of saints.

By contrast to his *Black Clock*, Cezanne's *Still Life with Primrose*,→ pp. 114/115 in which the layout of apples on a tablecloth resembles an abstract landscape—one might think of a moonscape with scattered rocks—seems presided over by a potted plant as if its leaves were arms directing the fruit into their varied sets and groups.

U  *Still Life with Apples and Primrose* c.1890
Oil on canvas  72 × 92.7 cm
The Metropolitan Museum of Art, New York
Bequest of Samuel A. Lewisohn

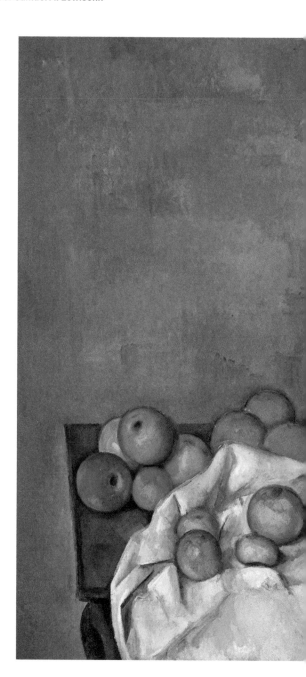

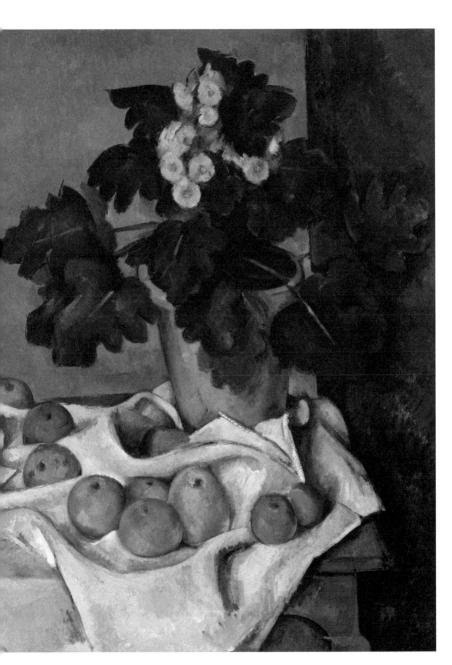

Seemingly random at first, upon contemplation the distribution of apples within the tablecloth reads like an orchestrated counterpoint, explaining how some interpreters compared paintings by Cezanne and some of his contemporaries to music. Although it may seem somewhat distance from what we regard as uncanny, the fact that a visual experience can at times evoke a different aesthetic plane might be argued to have something of an uncanny, or unexpected magic. It is worth noting that painting and music share a vocabulary—words such as harmony, tonality, and rhythm. In the late nineteenth-century, in fact, musicality was a widely sought characteristic for painting, emphasizing the abstract play of pictorial relationships rather than subject matter—and leading eventually to pure abstraction.

Of course, all such interpretations are human responses to inanimate colors applied to a woven (canvas) surface. It is through Cezanne's coloristic richness and subtlety, combined with his arrangements and distortions of form, that his painted compositions elicit responses that attribute weight and meditative seriousness to his vision—an experience that is riveting and defies easy categorization in words.

U   *Still Life with Black Clock*  1867–69
    Oil on canvas  54 × 74 cm
    Private collection

    *Card Players*  1890–92
    Oil on canvas  135 × 181.5 cm
    Barnes Foundation, Philadelphia

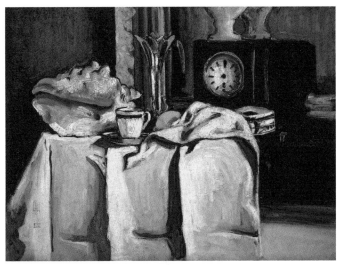

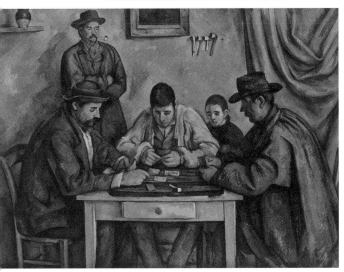

V → **Vollard, Ambroise
and Early Collectors**

Until he was discovered by the young, adventurous art dealer, Ambroise Vollard, in 1895,→p.122 Cezanne had little following. Early in his career, like some of his Impressionist colleagues, he had benefitted from the support of Doctor Gachet →Impressionism and the customs officer Victor Chocquet (advised by Pierre-August Renoir), who at one time had nearly forty works by Cezanne in his collection. Slightly later, the dealer-framer Julien (known as Père) Tanguy took Cezanne's pictures in exchange for art materials. It was at his shop that Paul Gauguin first encountered Cezanne's paintings and began to collect them himself. Still known mostly only within avant-garde art circles—Edgar Degas also bought his pictures—Cezanne painted primarily for himself, even more so once he withdrew to the Jas de Bouffan →Jas de Bouffan following the death of his father in 1886.

Like Cezanne, Vollard was an outsider—a native of France's African island colony of La Réunion. Having come to Paris to study law, Vollard eventually abandoned his studies to become an art dealer, starting out reselling works he picked up cheaply, then setting up on the Rue Lafitte, where other dealers were located, notably Paul Durand-Ruel, who represented most of the other Impressionists. According to legend, like Gauguin, Vollard first saw Cezanne's work at Tanguy's shop. Realizing that Cezanne was without a gallery, he bought some 150 works directly from the artist—almost his entire available

output at the time—which he exhibited by rotation to increasing acclaim from 1895. Cezanne's portrait of Vollard exemplified the artist's attitude. After approximately 140 sittings, Cezanne was satisfied only with his subject's white shirt. What better testimony to Cezanne's obsessive pursuit of perfection, as if imitating the failed hero of Zola's novel, *The Masterpiece*,→ Zola, Émile and raising the issue so often debated about what constitutes a finished work.→ Finito / Non-Finito

Vollard enhanced his own reputation by showing other Impressionists as well, and soon after began to acquire works by Picasso and Braque. At the *Salon d'Autumne*, which Vollard organized in 1905, he exhibited forty-one works by Cezanne. Gertrude and Leo Stein were among his early clients. Indeed, the golden age of Cezanne collecting was the first half of the twentieth century, when writers such as Roger Fry in England and Julius Meier-Graefe in Germany sensitized their publics to Cezanne's historical significance, and he was hailed as the modern heir to the classical tradition.→ L'Estache At that point collectors from around the western world acquired Cezannes in considerable numbers. Among the greatest were Oskar Reinhardt, Samuel Courtauld, Alfred Barnes, and later Emil Bührle and Ernst Beyeler, all of whom left their magnificent collections to institutions that bear their names and are open to the public. For many, however, Cezanne is still an artist's artist, collected by painters from Henri Matisse, who

bought early from Vollard (the price included receiving ten of Matisse's own works), to Jasper Johns, who can afford the current rates.

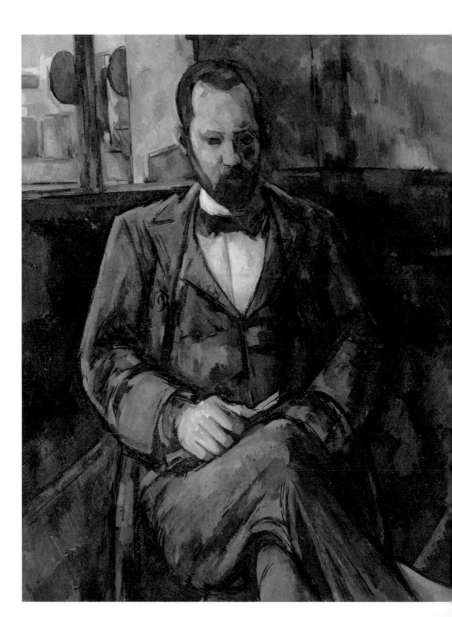

V  *Portrait of Ambroise Vollard*  1899
Oil on canvas  100 × 82 cm
Petit Palais, Musée des Beaux-Arts de la Ville de Paris, France
Bequest of Ambroise Vollard

w → **Water-based media**

More than any of the other Impressionists or Post-Impressionists, Cezanne experimented in the medium of watercolor. Whereas water itself was an important theme for several of his cohorts—one thinks of their many river scenes and, even more, of Monet's *Water Lilies*—Cezanne's affair with water had not to do with subject matter but with the materials and processes of art themselves. Taming a translucent and flowing medium to represent solid forms and spatial relationships was a perpetual challenge. Given their vast numbers, his watercolors bear witness to an obsession with the transformation from the real to the ethereal realm of art. They lie at the heart of his enterprise.

As with still life, which exemplified one sort of paradigm—namely, composition—→ Textiles the watercolor process embodied another, namely perceiving and studying form through light. The white background may be said to be like pure light as yet unbroken into its prismatic elements, or before some wavelengths are absorbed and the ones we see are reflected back. Hence watercolor pigments applied over white paper may more closely embody our perception of the world around us than the traditional, pre-Impressionist practice of painting from a dark ground to light. (The Impressionists prepared their canvases with white or light-colored grounds.) → Finito / Non-Finito Watercolor offered painters the opportunity to scrutinize and practice concentrated motifs or overall compositions they

might want to use for later oils, as if previewing them at the original moment of experience. Sometimes, the exercises were elaborate enough to have become finished works themselves.

Examples by Cezanne abound, as in *Rocks at Bibémus*.→pp. 90/91 Another, *A Group of Trees*,→p. 126 like all Cezanne's watercolors, began with a deftly light and generalized pencil sketch, and like most of them would not be considered a finished work.→Finito/Non-Finito The pencil marks serve merely as a general compositional guide. The patches of color do not necessarily follow them; color is not ruled over by line. The main effort of the areas of color is to create the effect of foliage through patches and slight strokes of related tones that suggest both the spaces and the masses that inhabit them. Many such studies focus on particular motifs that must have struck the painter's fancy, whether he later used them for painted compositions or not. Their value lies not only in their sheer and elegant beauty but in the insight they provide to the painter's working method, which his watercolors help us understand to be almost entirely color-based.→Ochre The balance between meticulous observation and the relatively spontaneous flow of the medium embodies both Cezanne's commitment to Impressionism and his development beyond it as he experienced both the mutability and continuousness of the natural world.

W   *Group of Trees*  *c.* 1900
    **Graphite and watercolor on paper  45.7 × 29.8 cm**
    **The Morgan Library & Museum, New York**
    **Thaw Collection**

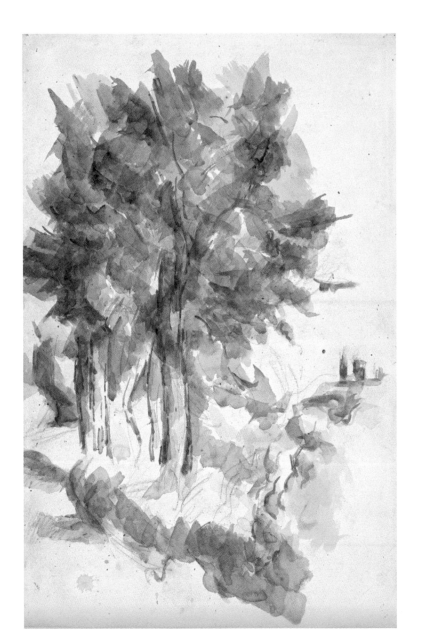

x → **X-Ray**

Radiographic evidence often reveals *pentimenti* in finished paintings—traces left behind when the artist has painted one composition over another. For example, the Barnes Foundation in Philadelphia discovered that Cezanne considerably diminished the proportions of the standing figure to the left in its version of the *Great Bathers.* →Bathers X-ray photographs reveal how he had painted the first trial over with the smaller figure. Another discovery revealed that Cezanne painted a view of the *Gulf of Marseille from l'Estaque* (The Philadelphia Museum of Art) over a vertical portrait of Madame Cezanne, perhaps because, being at a distance from Aix, he lacked fresh canvases, or because he was dissatisfied with the portrait.

Another kind of analysis is of materials. The age of pigments, for example, can help determine whether a painting is authentic, misattributed, or possibly a forgery. By spectrographic analysis or electron microscope, a conservation laboratory might demonstrate that a certain pigment did not exist in the time frame attributed to the painting or that it was too fresh to have been applied at the time. Pigment analyses of pictures by Cezanne reveal that he used a fairly consistent set of oil paints, especially lead white, vermillion, red lake, yellow ochre, emerald green, viridian, ultramarine, and carbon black. They also reveal that most of his canvases were commercially prepared with lead white. These are of course generalizations: circumstances

# Bibliography

As stated in my preface, a consensus of Cezanne scholars has recently decided that the accent over the first 'e' in Cezanne's name is not authentic. I have therefore not used it in my essays for this book, but I respect the spelling used in the following titles.

Amory, Dita. *Madame Cézanne*, exh. cat., New York: The Metropolitan Museum of Art, 2014.

Armstrong, Carol. *Cézanne's Gravity*, New Haven: Yale University Press, 2018.

Athenassoglou-Kallymyer, Nina. *Cézanne and Provence: The Painter in his Culture*, Chicago: The University of Chicago Press, 2003.

Bergson, Henri. *Essai sur les données immédiates de la conscience*, Paris: Félix Alcan, 1889.

————. *L'Évolution créatrice*, Paris: F. Alcan, 1907).

Bernard, Émile. "Une Conversation avec Cézanne," in *Mercure de France*, 1 June, 1921, pp. 372–397.

Blanc, Geneviève. *L'Oeuvre de Cézanne à l'Estaque : Huiles—Aquarelles—Dessins, 1864–1885*, Marseille: Éditions Gaussen, 2019.

Cezanne, Philippe. *Paul Cezanne dépeint par ses contemporains*, Lyon: Fage, 2021.

Conisbee, Philip, and Coutagne, Denis. *Cézanne in Provence*, exh. cat., Washington, D.C.: The National Gallery of Art, 2006.

Coutagne, Denis. *Cézanne en vérité(s)*, Arles: Actes Sud, 2006.

————, *Cézanne et Paris*, exh. cat., Paris: Musée du Luxembourg, 2011.

————, ed. *Les Sites Cézanniens du Pays d'Aix*, Paris: Réunion des Musées Nationaux, 1996.

Denis, Maurice. "Cézanne," (1907) in *Théories, 1890–1910, Du symbolisme et de Gauguin vers un nouvel ordre classique*, 3e édition, Paris: Bibliothèque de l'Occident, 1913, pp. 237–253.

Distel, Anne. *Un Ami de Cézanne et Van Gogh: Le Docteur Gachet*, exh. cat., Paris: Grand Palais, 1999.

Dombrowski, André. *Cézanne, Murder, and Modern Life*, Berkeley: University of California Press, 2013.

Feilchenfeldt, Walter, Warman, Jayne, and Nash, David, *The Paintings, Watercolors and Drawings of Paul Cezanne, An online catalogue raisonné*, https://www.cezannecatalogue.com/catalogue/index.php, (accessed February, 2021).

Fry, Roger. *Cézanne, A Study of his Development*, London: L. & V. Woolf, 1927.

Gasquet, Joachim. *Cézanne*, Paris: Bernheim-Jeune, 1921.

Geskó, Judit. *Cézanne and the Past. Tradition and Creativity*, exh. cat., Budapest: The Museum of Fine Arts, 2012.

Gowing, Lawrence. *Cezanne: The Early Years 1859–1872*, London: The Royal Academy of Arts, 1988.

Ireson, Nancy and Wright, Barnaby. *Cézanne's Cardplayers*, exh. cat., London: The Courtauld Gallery, 2010.

Leca, Benedict ed. *The World is an Apple: The Still Lifes of Paul Cézanne*, exh. cat., Hamilton, Ontario: The Art Gallery of Hamilton, 2014.

Lewis, Mary Tompkins. *Cezanne's Early Imagery*, Berkeley: University of California Press, 1989.

Meier-Graefe, Julius. *Paul Cézanne*, Munich: R. Piper, 1910.

Merleau-Ponty, Maurice. "Le Doute de Cezanne" (1945) in *Sens et non-sens*, (Paris: Éditions Nagel, 1966), pp. 15–44.

————. *L'Œil et l'esprit*, Paris: Gallimard, 1961.

Mothe, Alain. *Ce que voyait Cézanne: Les paysages impressionnistes à la lumière des cartes postales*, Paris: Réunion des Musées Nationaux, 2011.

Novotny, Fritz. *Cézanne und das Ende der wissenschaftlichen Perspektive*, Vienna: A. Schroll, 1938.

Pissarro, Joachim. *Cézanne and Pissarro: Pioneering Modern Painting, 1864–1885*, exh. cat., New York: The Museum of Modern Art, 2005.

Platzmann, Steven. *Cézanne, the Self-Portraits*, Berkeley: University of California Press, 2001.

Reff, Theodore. "Cézanne's Constructive Stroke," *The Art Quarterly* v. 25 (Autumn 1962), pp. 214–227.

Rewald, John. *Cézanne, A Biography*, New York: Harry N. Abrams, 1986.

Rishel, Joseph J. *Cézanne*, exh. cat., Philadelphia: The Philadelphia Museum of Art, 1996.

Rubin, James H. *Impressionism and the Modern Landscape: Productivity, Technology, and Urbanization from Manet to Van Gogh*, Berkeley: University of California Press, 2008.

Rubin, William. *Cézanne, The Late Work*, ex. cat., New York: The Museum of Modern Art, 1977.

Schapiro, Meyer. *Paul Cézanne*, New York: Harry N. Abrams, 1963.
_____. "The Apples of Cézanne, An Essay on the Meaning of Still Life," (1968) in *Modern Art, 19th and 20th Centuries: Selected Papers*, New York: George Braziller, 1978, pp. 1–38.

Shiff, Richard. *Cézanne and the End of Impressionism: A Study of the Theory, Technique, and Critical Evaluation of Modern Art*, Chicago: University of Chicago Press, 1984.

Sidlauskas, Susan. *Cézanne's Other: The Portraits of Hortense*, Berkeley: University of California Press, 2009.

Smith, Paul. "Cézanne's 'Primitive' Perspective, or the 'View from Every-where,' *The Art Bulletin*, v. 95, no. 1 (March 2013), pp. 102–119.

Société Paul Cezanne, *Cezanne Jas de Bouffan, art et histoire*, Lyon: Fage éditions, 2019.

Zola, Émile. *L'Oeuvre,* Paris: Charpentier, 1886.
_____. *Mon Salon*, Paris: Librairie internationale, 1866.
_____. *Mes Haines, causeries littéraires et artistiques*, Paris: Achille Faure, 1866.

Imprint

Concept   Ulf Küster
Copyediting   Hannah Young
Design   Torsten Köchlin, Joana Katte
Typeface   Scto Grotesk
Production   Thomas Lemaître
Paper   Munken Lynx, 150 g/m²
Reproductions   DruckConcept, Berlin
Printing and Binding   DZS Grafik, Ljubljana

© 2021 Hatje Cantz, Berlin and the author

Published by
Hatje Cantz Verlag GmbH
Mommsenstraße 27
10629 Berlin
www.hatjecantz.com

A Ganske Publishing Group company

ISBN 978-3-7757-4913-8 (English)
ISBN 978-3-7757-4912-1 (German)

Printed in Europe

Illustrations
Frontispiece
Paul Cezanne in front of *Les Grandes Baigneuses* in his studio at Les Lauves, 1904
Cover illustration
Paul Cezanne, *Madame Cezanne in a Red Armchair, c.* 1877 (detail), see p. 44